To: Lisa

love MIA

Lisa—

Thank you so much
for your work at
Mattel, and for being
part of the historic
launch of the Barbie
with Down Syndrome!
You are changing the
world for Mia and everyone
that rocks an extra chromosome! Much love, Cara Armstrong

Just Like You

TABLE OF CONTENTS

Introduction

The dictionary definition of Down syndrome is "a genetic chromosome-twenty-one disorder that causes developmental and intellectual delays." However, through the process of interviewing many prominent members of the Down syndrome community and their families, I have learned that the definition is missing a major attribute that I have seen in people living with Down syndrome: the capacity to forgive tirelessly, to love infinitely, and to move through the world with an open heart and present mind.

Ensuring that people with Down syndrome are acknowledged, understood, and encouraged is necessary for societal growth. As a majority-neurotypical civilization, we tend to get stuck thinking one way because our brains are hardwired to focus on the negative. To prioritize and represent only neurotypical viewpoints and intrapersonal dynamics is like painting with one color. For instance, blue is very pretty, but we humans have been gifted with a rainbow of colors! Our gifts create more beauty and expression in the world.

In essence, neurotypical and neurodivergent people are just like each other - we both strive for love, comfort, and a sense of belonging. We both struggle, we both laugh, and we both cry. We both learn from each other's differences. And we

both grow when we make an effort to understand and assimilate the positive traits of the other.

We are so lucky to be given the gift of each other. I feel so grateful to have gotten to speak with so many beautiful people and their families during the creation of this book. This project has widened my perspective exponentially and made me realize that what we consider normal doesn't have to be the norm, that we humans have an enormous capacity for change, and that human hearts are elastic - because, after every interview, my heart broke open and grew. The purpose of this book is to show society the importance of people with Down syndrome and to highlight the strength, humor, and hearts of several of these beautiful individuals. I thank everyone who was a part of this project. I thank everyone for reading this. To all I spoke with and the organizers behind this book, thank you for creating change in my perspective. I hope that this book can create change in yours.

Isabel Davison

Delmar DeWitt

I came from a family of seven children. Delmar was the fifth child, the only one of us with Down syndrome. I came along two years later as the sixth. DD became my brother's nickname because that was all I could say as a toddler. While that nickname began when we were young boys, Delmar was DD to me throughout his whole life. As a child, I was aware of our differences, but we simply played together and enjoyed each other's company. DD became my buddy and my forever protector. As I got older, this title of protector stuck with him, for he would stick up for me, even if I was having issues with the other neighborhood boys. His loyalty and love were unconditional, but he also enjoyed a little friendly competition. He was great at riding a bike, for we would constantly race each other, and he always won.

My family and I grew up loving our DD, and we quickly realized he was the most loving person in the family. His care and kindness shone through his actions. He endearingly called me his "Kid Brudder," and he would constantly ask, "How is my Kid Brudder today?" He was always making sure I was doing well. I truly realized how genuinely good his heart was when I tried to tease him by asking who he liked better: his brother or sister. DD never answered because he loved everybody equally and with passion. We learned the true meaning of love from DD, for he not only exuded love, but his character also inspired us to love.

DD asked the family to give him a job. His idea was to do the weather report for the family. We all watched the weatherman in the morning, which inspired DD to want this "job." My brother-in-law gave our family a large book, and DD dutifully wrote his weather report daily. Day by day, night by night, DD came into the room with his accomplishment, saying, "I did my weather report," as he excitedly showed me his writing, which was mostly scribbles. It gave DD a sense

of accomplishment because he had something to do, and he sure did it well. I still have that report book, and it is a treasure. His pattern of accomplishments does not stop there. DD was very skilled at telling exactly what time of day it was with no clock around, almost as if there was a built-in clock within him. We believed this to be one of his amazing gifts. Every night at seven o'clock, DD knew it was time to watch his favorite program, and he never missed more than two minutes of it, no matter what.

DD was an independent and capable thinker. We had a dog that DD claimed and loved as his own. Multiple times a day, my brother proclaimed that Tipper was his dog, not our dog collectively. He claimed us, his family, as his own and loved us just as much. DD did his weather reports, watched his special programs with joy, and cared for himself and all his needs. While he ate a little sloppily and needed small things here and there, DD was just like me; he was my friend, brother, and family. I grew up loving him and feeling abundantly blessed to have a brother who was different from me but one who inspired me and was stronger than me, something I found out when I attempted to wrestle with him (I always lost).

At the time of DD's birth, the world was not yet educated about Down syndrome. If a child was born with it, their parents shunned them from society, pretended they didn't exist, and placed them in an asylum disguised under the name of a medical institution. This was seen as a societal norm, but for my parents, that was never an option. He was my parent's first son and my first brother; he belonged to our family. Because of my family's ability to love my brother as a human, they became one of the first, if not the first family, to raise a child with Down syndrome in a home and not in an institution. I love my brother. To this day, I still cry at the sight of someone with Down syndrome because it gives me a rush of the incredibly fond memories I have from being a child with my best older "Brudder."

Larry Dewitt

Amy Bockerstette ——————

> 66

"I Got This!"

- Amy Bockerstette

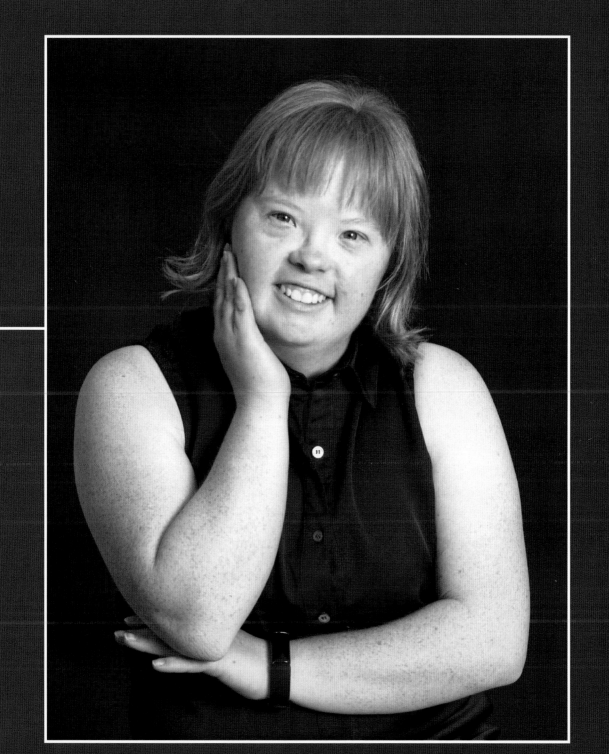

Amy Bockerstette

Amy Bockerstette, the twenty-three-year-old golfer who is a smashing success, has one of the most charming personalities a person could encounter. Her smile is pure loveliness, and with every glance, she radiates charm and easy amiability. Amy's parents recommend to fellow parents with children with Down syndrome that they "foster their child's interests and let them experience different things." Amy's life is a testament to the importance of that statement. After trying swimming, soccer, and volleyball, Amy started golfing with her family in the eighth grade at the age of fourteen, and they soon realized that she had something special.

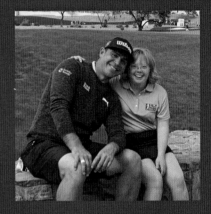

"You have to partner with your child to help them achieve the life they want," her father explains. She became the first person with Down syndrome to receive an athletic scholarship to attend college and compete in a national collegiate championship. When her athletic director was asked what it was like to have Amy on the team, she said that she's never met a player with whom everyone wanted to be their teammate. "She lights up the room wherever she goes," her parents tell us. "Amy exudes love, and it is unconditional. She's an example for all of us."

In 2019, Amy was invited to play the par-three sixteenth hole at TPC Scottsdale during the Phoenix Open practice round with professional golfer Gary Woodland. She hit her tee shot into the greenside bunker. While the crowd roared and the stadium hole shook in a frenzy, she parred the hole, exclaiming, "I got this!" Her serene confidence and ability to be fully in the present moment

skyrocketed her event into internet fame. When Gary Woodland won the U.S. Open months later, he credited Amy's positive energy and influence. "We won this together," he told her on the Today Show, his trophy in her hands.

Amy is a Special Olympics athlete in swimming, golf, and volleyball. She's also a piano player, a theater kid (performing in Legally Blonde, How to Succeed in Business, and Madagascar), and a major boy band follower (a lover of Big Time Rush and One Direction). She's also the spokesperson for the I GOT THIS Foundation, founded on her twenty-first birthday and named after her viral golfing moment. The foundation gives children with Down syndrome and other intellectual disabilities the opportunity to play golf. When asked what she would say if she could say anything to the world right now, she replied with good humor: "Hi, Gary. I miss you."

Her parents are proud: proud of her work ethic and proud of the joy that she brings to the world. There may have been people that were offensive or hurtful to Amy, but the Bockerstettes remain kind and wise. They advise "always look for intention and not necessarily the result."

"People with Down syndrome make us better people. We need to have these people in our lives - they can bring out the best in us, and we can learn so much from them. When Amy is included in something, she touches people, and they grow - they learn and expand their love and patience. The more people know about Down syndrome, the more accepting society will be."

Arik Ancelin

"It doesn't matter if you have a curveball in life,
you've got to make it your own.
If you find your passion, you can do
whatever you want to do."

- *Arik Ancelin*

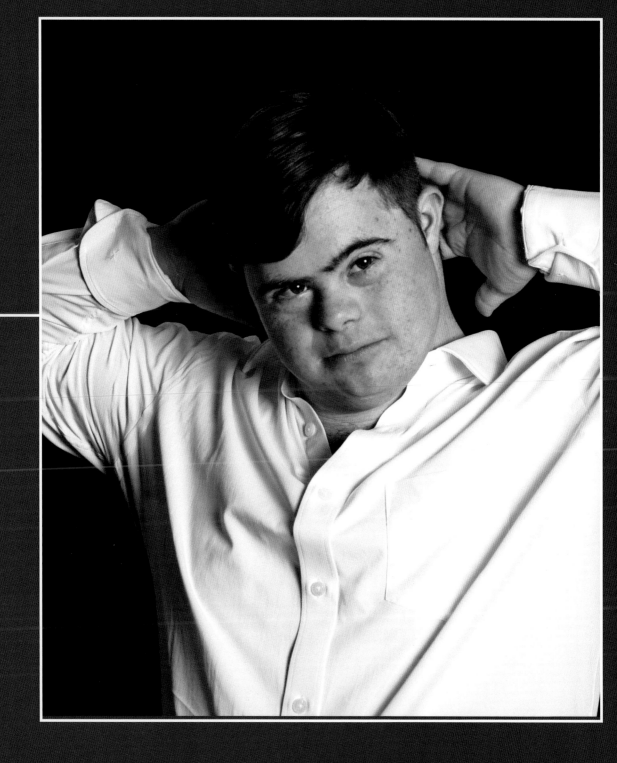

Arik Ancelin

Arik Ancelin, the nineteen-year-old TikTok star and rapper, talks with a cheery smile and clear, focused eyes. He dresses fabulously, and all who listen are enamored. With a warm and gentle voice, he shared his story about the moment that he knew that music was his passion. "I was in dance class, listening and dancing to the music there. I was thinking about the drive, the beat, and the rhythm of the music." Arik released his first song, "When I Turn 18," during COVID and started to gain a social media following. Then, he began working on his newest song, "True Colors," which, after its viral release, he performed with DJ Nitti Gritti. "It started to get a very big buzz, and the rest is history," he said.

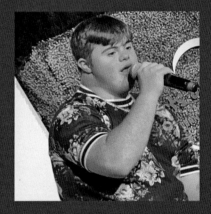

"True Colors means I am just a nineteen-year-old man and am starting my own career, and I want to show how different I am. My mission is to bring goodness to the music scene, to bring a bigger amount of love. I want to show them that having a disability can be a good thing in life. You can be yourself; you can be different."

When Arik was born, Jennifer Ancelin watched her son carefully. He was quiet and thoughtful, and the thought that kept running through her mind was that he didn't look like his sisters. When his doctor told her that Arik may have Down syndrome, Jennifer was flooded with emotions "with the gentlest yet fiercest maternal love. It was indescribable", she shared. She knew at once that Arik would teach her that a human's capacity to love is infinite. People fear the unknown. People fear

what the unknown may show about themselves. But the unknown must be embraced, for it is ever-present in life's journey. "Life's journey will unfold in ways we can never imagine. We will miss out when we worry through the journey. Life is about enjoying the journey. That is the greatest thing Arik has taught me," Jennifer says.

Arik earned a third-degree black belt in Taekwondo and will graduate from a career high school with certifications in construction. His sister speaks fondly of her memories with him, of all the fun they had despite the pain she felt when she saw how others sometimes treated him. But she speaks of how having a brother with Down syndrome taught her patience, to give people the benefit of the doubt, to always have perspective - just knowing how hard Arik works at things that may come naturally to others inspires her to work harder, and to be a more loving, non-judgmental person.

Arik's mom, Jennifer, explains that the ability to diagnose Down syndrome in utero is leading to a decline in the Down syndrome population. "Being born typical is a miracle. A hundred things must go right for that to happen. Disability is a natural and necessary part of the human experience," she says.

Arik says that if he could say anything to everyone in the world, it would be, "You only have one life. Don't let anybody take it away from you."

Camry Cheatham

"Camry has always been positive and uplifting, and that inspires me to keep up my spirits."

- Casey Cheatham

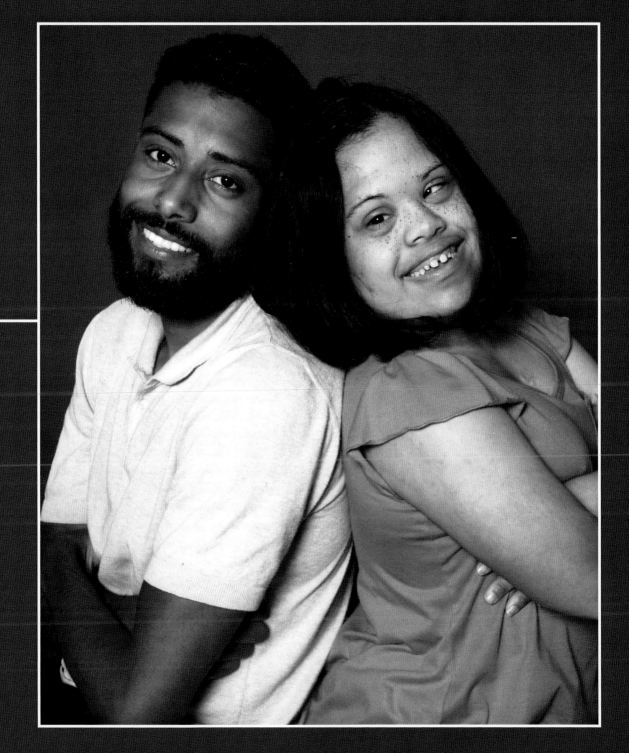

Camry Cheatham

Fraternal twins Casey and Camry were separated at birth. Until third grade, they lived in two different boroughs of New York City, sharing only their summers together. Now they sit side by side, smiles wide, as they tell their story.

At the time of the twins' birth, public education on Down syndrome was almost nonexistent, so when the doctors recognized that Casey was neurotypical and Camry likely had Down syndrome, it was seen as bad news. Their mother became emotionally distraught about Camry's Down syndrome diagnosis, so the family decided it would be a better fit for Camry to live with her paternal grandmother in Queens and for Casey to grow up in Brooklyn. The two grew up not really understanding the separation.

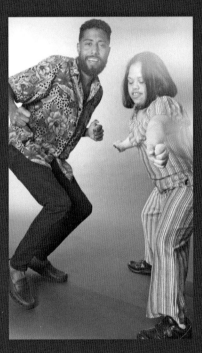

Their grandmother owned a daycare, so Camry grew up playing with other kids of all ages. Casey reminisces about their summers together go-karting and taking trips to Disneyland. Camry recalls her favorite moments playing basketball with her brother, having their cousins over, and dancing for hours. In 2001, their grandmother died, and the twins lived under the same roof for the first time in their lives.

Their mother, who wasn't initially sure about Camry, now shares a nice relationship with her. Casey believes that Camry has brought him to the understanding that "everyone has a capacity for love in a higher sense" and that she is an example of someone who exudes a love that heals. Nowadays, the family has moved to L.A., and the twins still live together. Camry loves to swim, draw, watch shows on Hulu—Desperate Housewives and Glee are her favorites—and dance with her brother. The two share plans to camp together in the future, as Casey wants to share his love for the natural world with his sister. They have a strong affection for each other.

Casey says that Camry has taught him patience, respect for people with disabilities and shortcomings, and to show unconditional love. Having Camry in his life has shown him that everyone is dealing with their own issues, so it's best not to always take others' reactions too personally. "Sometimes everyone needs to sit down and revisit a situation with love, and I believe that having patience is the foundation to build those skills," Casey says. He wishes that modern society could adopt his sister's patience in abundance.

"It's important to give back and support people with Down syndrome and their families because some families struggle financially or emotionally. People with Down syndrome have regular emotions. They just require a little more attention and time to get on their feet."

20

Perspective

"There is no greater disability
in society than the inability to see a
person as more."

-Robert M. Hensel

Mia Armstrong

"Down Syndrome is my superpower!"

- Mia Armstrong

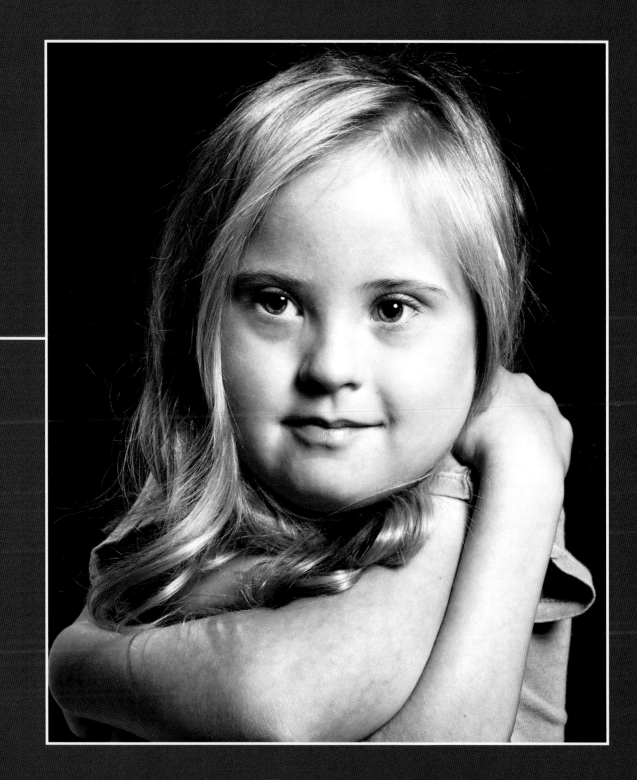

Mia Armstrong

It is not coincidental that the word 'strong' is part of Mia Armstrong's name. Mia is a direct result of what happens when you don't let the world's opinions get in the way of your character development and success. She calls Down syndrome her superpower, and everyone she encounters knows it. Her love and care for people, mixed with her extroverted personality and hilarious jokes, make her an incredibly inspiring eleven-year-old.

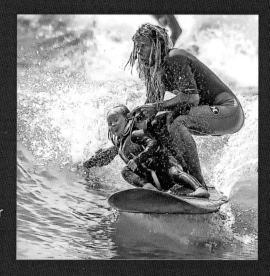

Before she was born, her mother endured a roller-coaster pregnancy full of doubts, challenges, and other people's unsolicited opinions. Cara, Mia's mom, believes that God put Mia in her life for a specific purpose. She is grateful for Mia's incredible capacity to change the perception of Down syndrome. Cara experienced this firsthand. Before Mia, she had never been exposed to the beautiful vivacity for life that she experienced with Mia and many others in the Down syndrome community who have been nurtured. Cara's only previous experience with Down syndrome was having yearly meetings with a young woman who had been institutionalized shortly after birth. This young lady had many behavioral and verbal complications, which Cara believes were partly due to never having had the experience of living and consistently being loved by a family.

Mia exceeded the expectations of her doctors, who predicted that her quality of life would be lower than the norm. Cara looked at her daughter with eyes that saw beyond the extra

chromosome, eyes that loved her for who she is, not who she isn't. Mia has an incredible ability to communicate with eloquence that is articulated through her powerful but loving voice.

At only eleven, Mia has been cast in commercials and print ads for Tommy Hilfiger, Walmart, Osh Kosh, Amazon, Cheerios, Samsung, Walgreens, Chase Bank, Teleflora, Target, and many other legacy brands. Mia has also been a guest on ABC's The View, The Stephanie Ruhle Show on MSNBC, and The Tamron Hall Show. In an interview with Good Morning America, Mia first shared, "Down syndrome is my superpower."

In 2022, Mia presumably made history as the first child with Down syndrome to be the voice of the cartoon character Eon on the hit show Action Pack on Netflix. Eon is a superhero with Down syndrome that has the ability to manipulate time. This groundbreaking work resonated deeply with the Down syndrome community. Children with Down syndrome had never before seen a face like their own on a cartoon. The writer of Action Pack, Shea Fontana, was inspired to create a superhero with Down syndrome in honor of her brother who also rocks an extra chromosome.

Cara believes that the first step to being accepted is being seen. "Diversity, equity and inclusion in media representation are important catalysts for social change. I like to remind people that"Down syndrome is not a tragedy, but ignorance is."

Mia is an incredible sister to her older brother, Jack, and her older sister, Amber. Her family enjoys the fullness of Mia's capacity to love, adapt, learn, and respond. She can sense when someone, even a stranger, is feeling down and knows exactly when to give hugs.

Mia is beautiful; she is mighty, and she is making a change within her community and around the world.

Grace Key

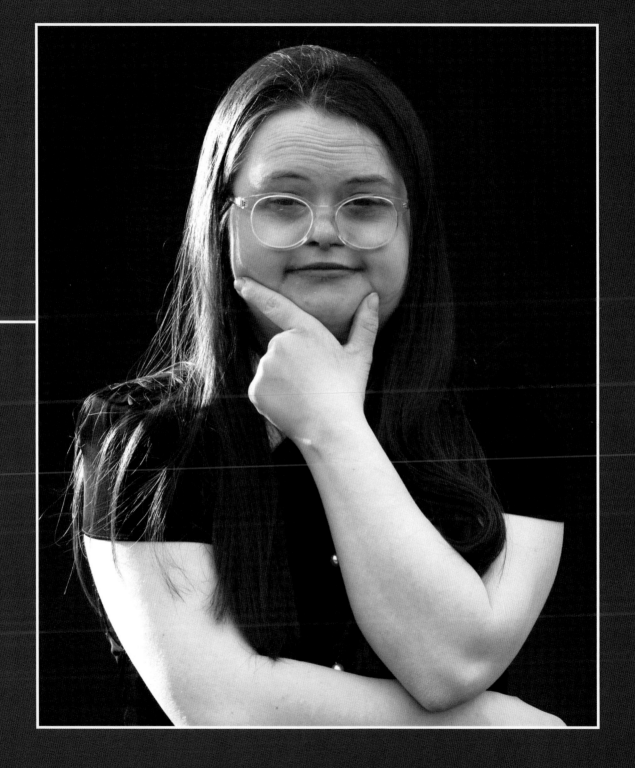

Grace Key

Grace Key wears hot pink lipstick and lays against her mother, Carrie Key. Despite the length of hours traveling and the subsequent tiredness that the two women were feeling, the wit that Grace interjected into the conversation brought amusement to all. The twenty-four-year-old owns and designs the clothing brand Candidly Kind with her favorite person, her mother, who she playfully calls her "business partner."

Grace grew up in Georgia as a devoted football follower and painter. In high school, she joined the cheer squad, and there, the cruelty began. She practiced with the team, but during the games, the cheerleaders shouted on the sidelines, and Grace stayed hidden on the other side of the fence. During halftime, Grace was forced to sit in the stands. Disgusted at her

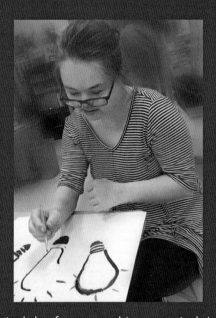

daughter's treatment, Carrie took a video of Grace cheering behind the fence, and it went viral. In her senior year, individuals attempted to block Grace from joining the squad. When Grace joined anyway, some of her teammates began to bully her, taking squad pictures that excluded her and creating fake social media accounts to provoke her and her family.

Carrie discussed what to do about this situation with Grace, who ultimately decided to quit the squad because of the bullying. While Grace should never have had to endure that situation, she did not let it break her and never lost her kind spirit. One afternoon, the idea of Candidly Kind struck her like lightning from the heavens.

"Grace has the most beautiful and forgiving heart that's so beyond everything," Carrie tells us, adding that if the girls that bullied her walked up to Grace right now, Grace would talk with them and be kind. She says that it is because, in Grace's eyes, nothing can interrupt the beauty in the world, despite the pain she might experience. "With Grace, you realize what's important in life: to stop and smell the roses and take in the beauty of people and nature. And she did that for everyone in our immediate and extended family. You have a lot more compassion and empathy toward people you didn't truly understand before and the things they may be going through. You have less judgment in your soul."

The first design for the Candidly Kind clothing line and the campaign was created by Grace right after her final high school football season, and it was released in the spring of 2018. Grace was able to draw out positivity from a negative situation. She is spreading joy and love around the world, one shirt at a time. A portion of every sale goes to charities such as Ruby's Rainbow, Gigi's Playhouse, and Best Buddies. Candidly Kind donated more than $55,000 to these organizations in its first four years of existence. In a beautiful twist of fate, Grace donated to the hospital where she had her open-heart surgery as a baby.

If Grace could say anything to the world, it would be to "love everybody." The Candidly Kind mission is "to spread light, love, and acceptance through Grace's art and life." This has been Grace's mission since starting this company in 2018, and it has been a blessing and a fulfilling outreach for Grace and her family. Grace's story is not just about overcoming adversity in life, it's also about using that adversity as motivation to change the world, educate the world, and spread kindness. Grace found her voice, and she's found her purpose too.

Jamie Brewer

"When it comes to diversity and disabilities, we always need to find a way to express who we are in our own ways."

- Jamie Brewer

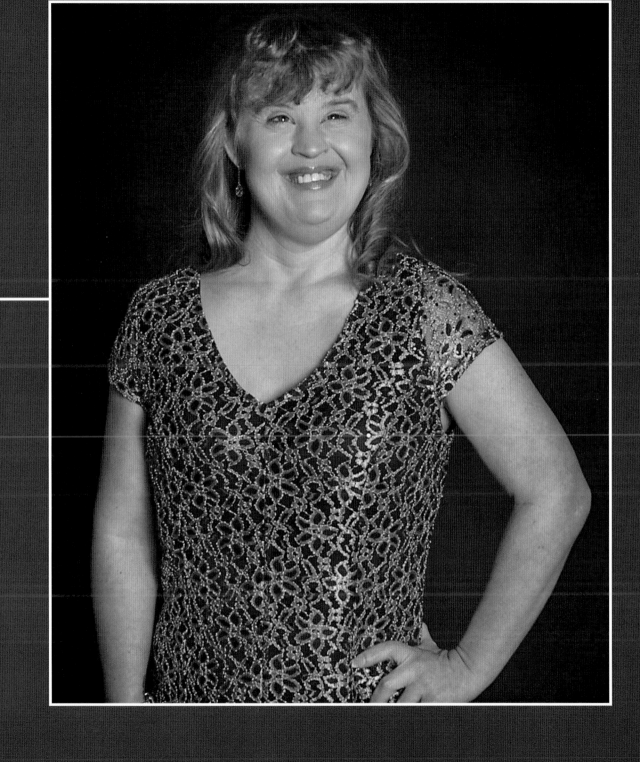

Jamie Brewer

The mood becomes instantly lighter when the beautiful Jamie Brewer enters the room. This actress and advocate started theater classes at just fourteen years old, eventually being cast for various roles in American Horror Story. She appeared in the TV shows Southland, Raymond & Lane, and Switched at Birth and made her off-Broadway debut in Amy and the Orphans.

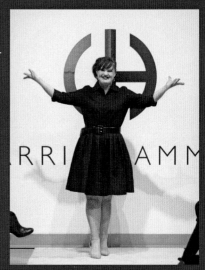

Jamie is a catalyst for change; because of this, her life includes a lot of firsts for the Down syndrome community. She was the first woman with Down syndrome to walk the runway during New York Fashion Week in 2015. She introduced Miley Cyrus at the Variety Power of Women event in 2016, and in 2018, she received the Drama Desk award for "Outstanding Featured Actress."

Beyond her career accomplishments, Jamie is respected for her tireless efforts to radically change the global negative perception of the lives of people with Down syndrome. She received the

Quincy Jones Exceptional Advocacy Award from the Global Down Syndrome Foundation for her contribution to improving human civil rights. In 2018, Jamie participated in the "Spread the Word to End the Word" campaign, a movement to eradicate the use of the words retard and retarded in society. She lobbied lawmakers for more respectful language regarding disabilities. Through Jamie's campaigning efforts and involvement with lawmakers, the "R-word" has been officially removed from Texas law and changed to "intellectual developmental disability" in Texas legislation.

When she has a goal in her sights, Jamie has proven that she has the ability to make the change. She is an incredible speaker and spoke in public service announcements (PSAs) for the Caring Houston Food Drive during the Super Bowl, which aired on NBC, ABC, and CBS.

Jamie is strong, beautiful, eloquent, and radiates positivity to everyone she meets.

34

Inspire

"Words can inspire. And words can destroy.
Choose yours well."

-Robin Sharma

Jaxon Bell

"Jax's dad wanted a son to play baseball with, and Jax now plays baseball, never underestimate the power of the heart."

- *Denise Bell*

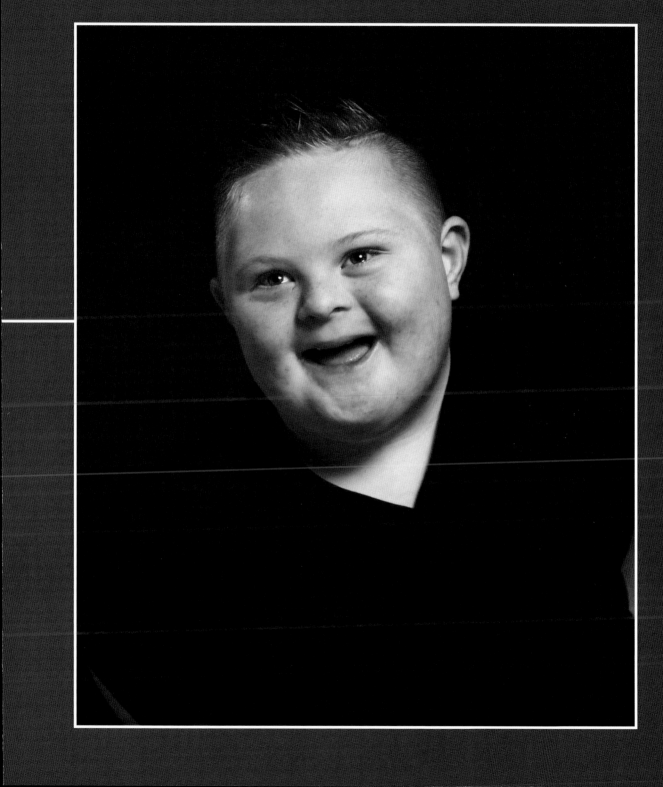

Jaxon Bell

The heart of the story between Jax and his mother, Denise, is love, determination, and inspiration. Denise and her husband had fertility issues, but Denise did not lose hope.

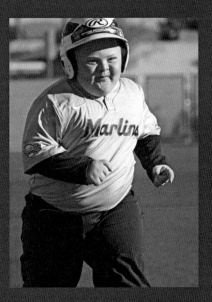

During her pregnancy, Denise decided not to be screened for fetal anomalies because she knew she wanted her baby either way. However, in her ultrasound at nineteen weeks, the doctors discovered that her baby would have Down syndrome. The doctors told Denise that her son had medical issues that were "not conducive to life." She told them that she would have her baby regardless. They pushed further by saying that the only thing "right" about the baby was his kidneys. Denise stood up for herself and told them that "they would at least have a kidney donor then." Months later, she gave birth to a beautiful baby boy, the boy that she had been waiting for all those years. Denise named him Jaxon and called him Jax for short. Denise shared that her side of the family accepted Jaxon immediately with love and care, but her husband could not and eventually left their family.

While Denise was heartbroken he left, she remained strong for Jaxon and continued to raise him on her own with the unwavering support of her family. Jaxon has an older brother, Ryan,

who inspires him with his work in the Army, and an older sister, Makenna, who loves him enthusiastically. Denise's brother, Dennis, lovingly embraced the role of father figure to Jaxon, and his wife, Alyssa, helps ensure Jaxon never experiences any void in his life. Denise's parents were ever-present and a part of Jaxon's daily life until their unexpected passing within a short time. As Denise mourned the deep loss of her parents, her incredible young son brought her the greatest comfort and is the beneficiary of the love she carries in her heart.

Despite their hardships, Denise and Jaxon have persevered. A special education teacher, Denise had already chosen a path for herself to serve individuals with differing needs, but it also uniquely prepared her to raise Jaxon as they both experience a full and wonderful life of passion and joy, as well as love for each other.

Today, Jaxon plays baseball in a local Special Education league. He loves to give big hugs and brings light into every room he enters. His beautiful soul shines through when he talks to people around him, but most of all, he loves his mother.

Matthew Blascovich

"Matthew is incredibly forgiving, loving, and able to see the good in people - he's simply on another level."

- Jessamy Tang

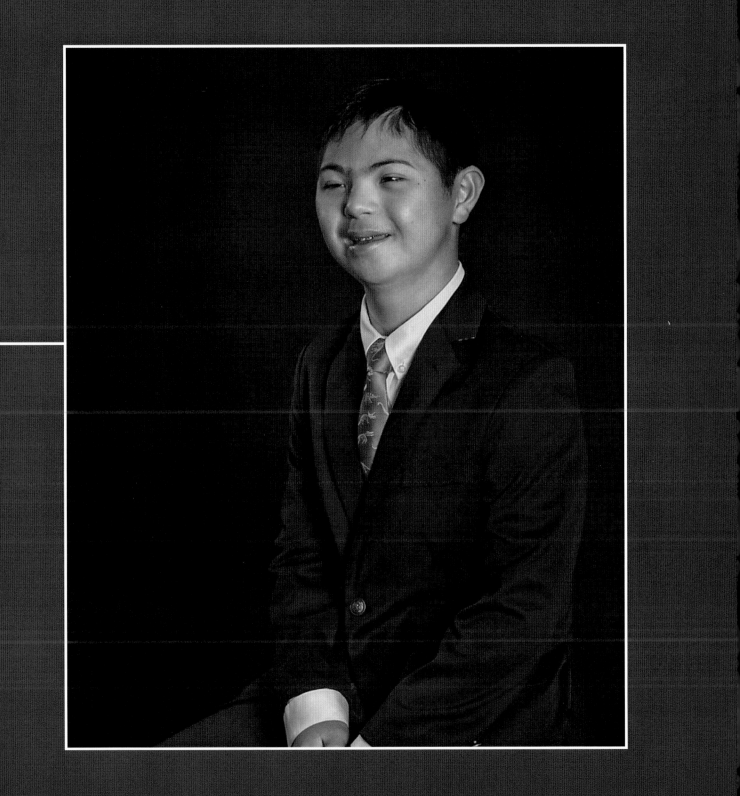

Matthew Blascovich

Thirteen years ago, Jessamy Tang was told by a doctor covering for her primary obstetrician that her baby's potential Down syndrome would ruin her life. Today, Matthew Blascovich of the Matthew Foundation is tidy, handsome, and full of the spunky mannerisms of a teenager coming into his own. He's a skier, a swimmer, a lover of lions and the color green, and playing outside on the swings and the monkey bars. He is enamored by airplanes and is curious about all the new locations that they could take him and how they can soar above the clouds. Jessamy is blown away by Matthew's capacity for forgiveness and love and his inexhaustible ability to see the good in people.

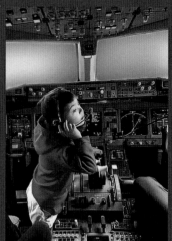

When Matthew was seven, his family moved to London. His younger sister had a fear of the dark, so she often woke him up in the middle of the night, insisting that he walk her to the bathroom door. Tirelessly, night after night for a year straight, he got up out of his warm bed and accompanied his little sister to the bathroom door without a word of protest, with gentle care and devoted patience.

At a recent meeting with his public school teachers to determine his class placement, one of his teachers assumed that because Matthew sat near the emergency exit, he was going to flee. "Did

he?" Jessamy asked. "No," the teacher responded. This insulting treatment of him was part of the reason the Matthew Foundation was started. The Blascovich family got involved with supporting research to improve cognition as soon as they discovered that Matthew had Down syndrome. This led to Jessamy being asked to join the board of Down Syndrome International and co-chairing the first World Down Syndrome Day at the UN. From there, the Matthew Foundation was started to further support the Down syndrome community.

"Matthew thrives when people believe in him and give him the opportunity to learn and develop. When he gets the confidence to do something, he tries even harder, and he's able to achieve more. If you believe they're incapable, then they're going to be incapable."

Matthew loves the changing of the guards at Buckingham Palace. He told us that if he could do anything in the world, it would be marching. "Do you want me to demonstrate?" he asked. We all nodded, so he got out of his chair and proudly marched away.

Mindy Zazanis

"Down Syndrome feels like a community where I can thrive."

- Mindy Zazanis

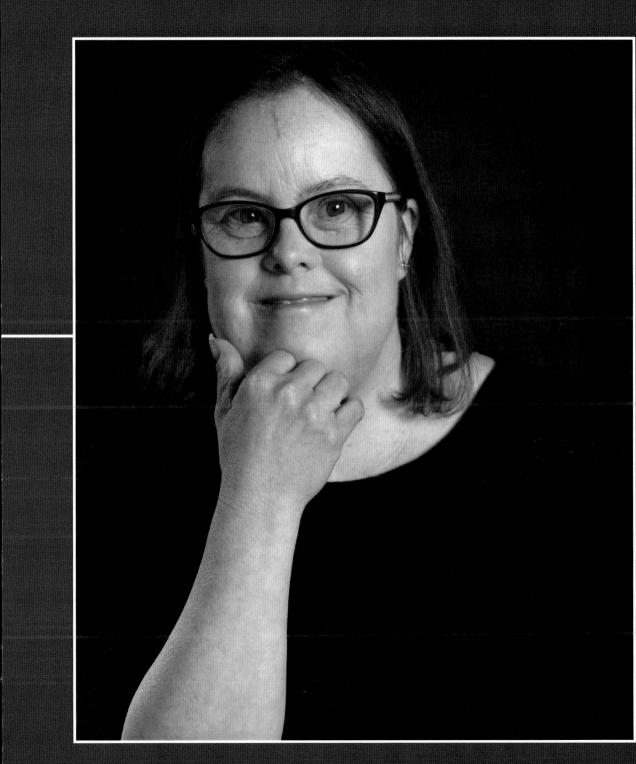

Mindy Zazanis

Hard work is derived from the passions of people who desire to achieve something. They have a dream to catch, an end to reach, and a goal to strive for. Mindy is the embodiment of this and has been for forty-four years. When we first met Mindy, she was ready to take her portrait. The atmosphere she brought into the studio was lively and optimistic. Through her dancing, smiling, and posing, she was able to bring a smile to all of our faces.

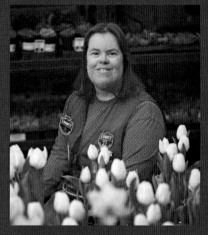

As a worker at Lowe's for fifteen years in Burbank, California, Mindy radiates eagerness and excitement throughout the store as she performs her duties. Working in a retail environment, Mindy has been building her communication skills, familiarizing herself with hardware and equipment, and learning about customer service. She also has greenhouse tasks where she waters rows of plants and trims stray leaves. With this job experience, Mindy shows her love and care toward all living things.

Mindy loves connecting with people. She is a social butterfly seeking new friendships and easily bonds with others. She started acting when she was nine and secured a role on the series 7th Heaven. As she got older, she decided to focus more on her career at Lowe's and less on acting. Mindy is also incredibly athletic. She has participated in many sports, including horseback riding and golfing, and she is an enthusiastic and passionate fan of the LA Dodgers baseball team. In her free time outside of her job, Mindy regularly meets up with her friends, most of whom also have Down syndrome. "It feels like a community," she says.

Mindy is well-rounded, responsible, and kind. She is a great auntie and friend. She is also a spokesperson for the Special Olympics, which inspires people. Mindy has a list of goals that she wants to pursue, including working in the office at Gigi's Playhouse, Simi Valley, a nonprofit Down syndrome achievement center for incredible people like her.

48

Worthy

———

"Sometimes the hardest part of the journey is believing you're worthy of the trip."

-Glenn Beck

Paislee Karaba

> "She's a fighter."
>
> *- Alanna Karaba*

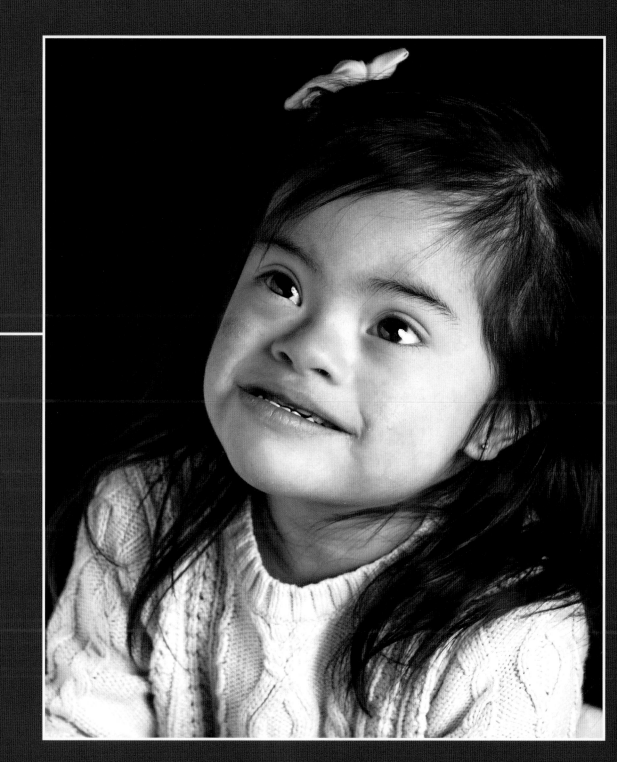

Paislee Karaba

Alanna was born in Simi Valley, California, where she raised six biological kids and worked as a professional nurse. Although happy, Alanna felt there was more in store for her life. Then she met Paislee. Beautiful baby Paislee was her first placement as a foster parent. Paislee is the fourteenth child of a homeless, drug-addicted mother and was born weak, living in the NICU for the first three months of her life. Paislee evoked such a sense of motherhood within Alanna that she knew from the moment she saw her that she would never give Paislee back to the foster care system.

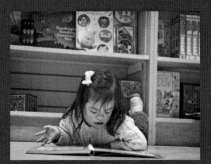

Alanna fought tirelessly through paperwork and the courts to keep Paislee and adopt her a year after she carried her home out of the NICU. Having children ranging in age from thirteen to thirty-two, a newborn baby was not easy to take on. As a nurse, Alanna aided in the birth of a friend's daughter who has Down syndrome and had already experienced firsthand how incredible people with Down syndrome are. When she discovered Paislee was a part of that community, Alanna immediately called her best friend, sobbing with joy.

Alanna realized that this adoption was more important to her than her job. She felt it was a higher calling for her to connect with the foster care community and leave full-time hospital nursing. Paislee was born early with Down syndrome and endured heart surgery; she is a conqueror. While she was afraid of the heart condition, Alanna was never scared to have a child with Down syndrome because she knew her connection to Paislee was meant to be. Paislee's doctor was supportive and helped the family through the entire process. Alanna still remembers Paislee's adoption day as one of the most pivotal moments of her life.

Paislee has developmental and physical therapy twice a week. Right when she needed it, a speech pathology center opened close to her home. Paislee is now three years old and is entering special-education preschool, which will prepare her for integrating into other schools later on. At such a young age, and with some therapy halted during COVID, it is hard to tell what Paislee's capabilities will be. Alanna looks at her situation confidently, secure that it will work out how it is supposed to, just like it has for the past three years.

Alanna's experience differs from that of a mother who gave birth to a child with Down syndrome because Alanna chose to adopt this baby. She considers Paislee one of her greatest blessings because she brings so much joy to their family. Alanna is grateful to her amazing husband Jay (who is an emergency room charge nurse) and her kids who unanimously thought the decision to adopt was the right one as they all wanted to make Paislee part of their family.

Even though Alanna knows that this adoption was a God-given gift, there are moments when she feels doubt and worry. She worries about being enough for her baby, and about being equally supportive to all of her kids and grandkids, as it can be a lot to juggle. But it is a struggle where the blessings far outweigh the hardship.

Adopting is scary, but despite this, Paislee's family is ready to have Paislee with them for the rest of her life. Alanna knows that Paislee will always love her as her mom. She communicates, recognizes her daily routines, and she is very present even though she doesn't talk. Paislee loves music and is quite a dancer. She knows what books she wants to read each night and is a capable toddler.

Paislee is part of the family. She now has six siblings, a loving mom who gave up her job to be with her, and a loving and supportive father who aided Alanna in following her dreams of mission work within her own California community.

Sophie Samaan

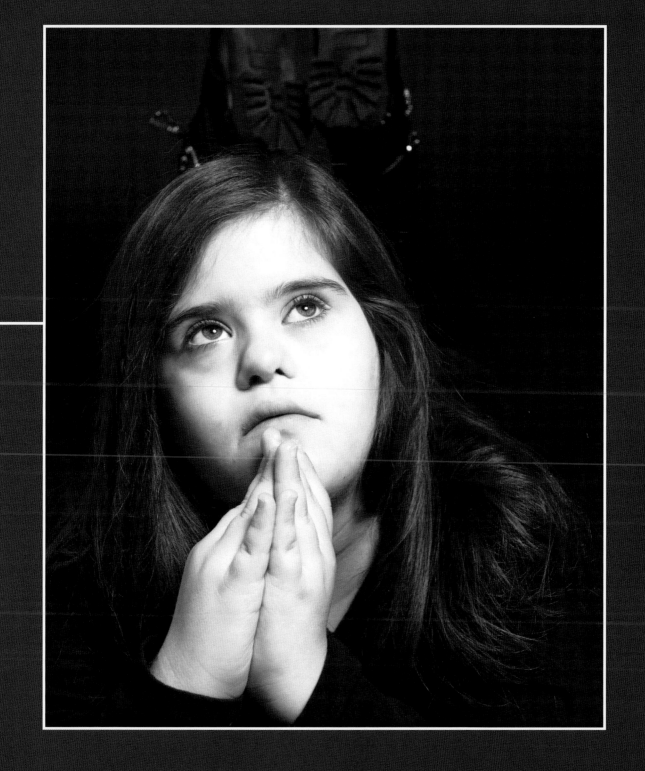

Sophie Samaan

Laurie Samaan was forty-seven years old when, on Christmas Day 2011, she got a strange feeling and took an expired pregnancy test. A faint line fulfilled her deep desire for another child. Frantically, she ran to the nearest store for a fresh test. The line popped up immediately. For days, she and her husband were utterly speechless. Upon hearing the heartbeat at her first prenatal appointment, Laurie knew that her baby was a longed-for gift.

At her fourteen-week prenatal appointment, the doctor explained to Laurie what he saw on the ultrasound. There were folds in the baby's neck which is a marker for Down syndrome, and one heart chamber was abnormally smaller than the other. There was also a vein that the doctor had never seen before. It wasn't connected to anything, and the doctor suggested that it was not conducive to life and the baby would likely not survive. As he spoke, Laurie felt herself slipping into shock. Her ears began to ring, she could not speak, and she was vaguely aware of a single tear running down the side of her cheek. The doctor asked her three times if she wanted to terminate the pregnancy. Laurie found her voice enough to shake her head each time and squeak out a feeble but audible "no." She would not give up on her child. Even with the support of her friends, this news was crushing to Laurie and hard to process. Laurie realized that it was not Down syndrome that she was afraid of but rather society's response to it. As she thought endlessly of the possible issues her child might bring to their family at birth, a sense of wisdom came over her that said, Don't worry about the what-ifs, just deal with what is in front of you. As God spoke to her, she heard in her heart, I chose you for this. At that moment, Laurie realized her baby would have a purpose within the Down syndrome community, and with that, so did Laurie. Laurie went from a place of grief to full acceptance and excitement for her baby to come.

At the next prenatal visit, the doctor could no longer see the mystery vein and the baby's heart looked completely normal. At that point, Laurie trusted the journey she was on. Laurie admits to feeling what many parents experience when they are told their baby will have a birth defect. She felt like she might burden others, that she might bring shame to the family, and that it might be selfish to bring Sophie into a difficult life. However, when Sophie was born, all those questions fell away.

Laurie put Sophie into their local preschool at two years old, and everyone involved was surprised to see how well Sophie did in class. She knew her seat was on the red triangle, she climbed on the monkey bars, fed herself, and rode a tricycle. She was inspired by her peers daily, and her environment allowed her to go beyond everyone's expectations. Sophie was always ready to move up and progress, just like everyone else.

Sophie is now a thriving 4th grader at her school, where she is the first child ever to have Down syndrome and is fully included in learning alongside typically learning peers. With the support of an aide, speech therapist, and teachers who have embraced her in their classroom, she continues to shatter people's low expectations and change how Down syndrome is viewed, one person at a time. Laurie encourages Sophie's teachers not to feel the pressure to have Sophie keep up with the class but to instead focus on making consistent progress in her learning. Each day is a new opportunity for Sophie to rise to the occasion, whether with her reading and math, using a computer, or participating in dance class or church choir.

Sophie has a kind heart and does not let a stranger's stares affect her. Each person she passes is greeted with a warm hello, accompanied by a smile that melts hearts. Her kindness sparks joy within others, which helps them to see past her Down syndrome, and instead, they just see Sophie.

Tim Harris ———————————————————————————

> ❝
>
> "I have Down Syndrome.
> I am Awesome."
>
> *- Tim Harris*

Tim Harris

Tim Harris is a born entrepreneur, but the trait that stands out more than that is his kindness. With support from his family, Tim was able to open his own restaurant. Unlike a typical restaurant, Tim added his own unique style. He made sure to hug and greet every person that entered his restaurant and was able to successfully grow his business based on his ability to spread love. He wanted everyone who came through the door to feel welcomed and loved.

Tim succeeded in becoming the best entrepreneur and hugger his town had ever seen and even received global attention for his hugs, eventually receiving an invitation to the White House to hug then-President Obama.

Inspired by his followers, Tim decided to close his business to spend more time traveling and speaking. He is passionate about spreading hope and inspiring others to live their best lives and to dream big.

Tim is also a philanthropist and activist. Hearts of Joy International is a nonprofit organization that has performed more than seventy life-saving surgeries for children with severe heart conditions related to Down syndrome. Tim has teamed up with the founder of Hearts of Joy, Lauren Costabile, to lead multiple events together. One of their more prominent events was a gala with guest speakers and singers, and their next dream is a planned hug-a-thon in Los Angeles to spread awareness for people with Down syndrome worldwide.

Tim is sweet, kind, and selfless. His hugs evoke a sense of belonging, and he touches the hearts of everyone he meets. His jokes and laughs are contagious, along with his catchphrase: "Oh yeah!" He uses this phrase with his fist in the air to show his excitement about being surrounded by people he loves so much. His hugs are not only a source of hope and joy, but they also represent the people in the Down syndrome community and their collective sense of empathy for others.

Brave

———

"Only when we are brave enough
to explore the darkness will we discover the
infinite power of our light."

-Brene Brown

Troy Drake

"Don't be the best, do your best."

- *Troy Drake*

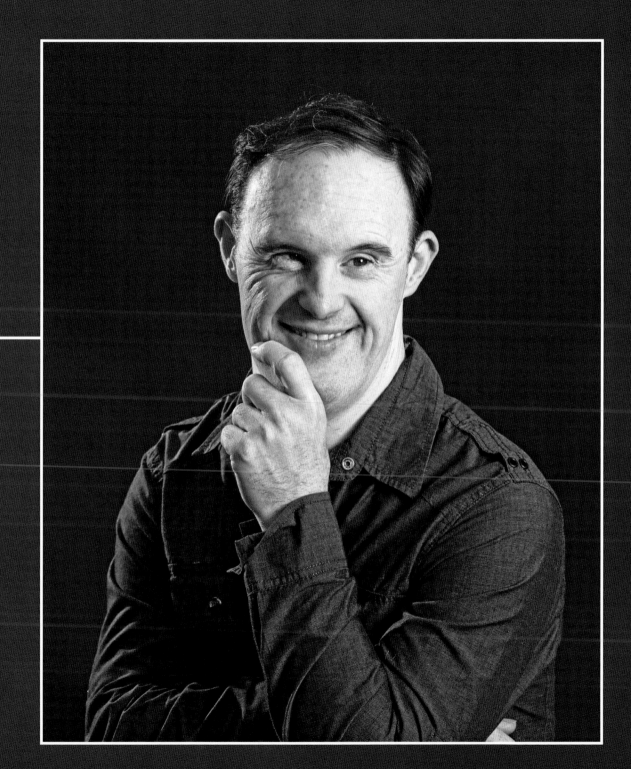

Troy Drake

When a new pottery studio opened half an hour from town, Troy Drake accompanied his parents to the class. While his parents were throwing pottery on a wheel, Troy was given an opportunity to hand-build. He had always been artistically inclined - he had drawn for as long as his mother, Suzanne, could recall - but pottery was something new. It became a hobby for him. He started to take regular classes. That Christmas, Troy made ornaments, and Suzanne posted a few to Facebook in case family and friends wanted some. From there, the 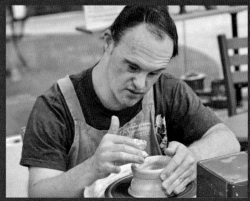 tale of Troy Drake's ornaments grew wings and flew. Troy ended up selling a whopping $1,700 worth of ornaments!

Then, with the help of his sister's friend, Troy suddenly had an Instagram account. "You need to show everyone the capabilities of people with Down syndrome," she explained. They did. Videos were posted of Troy making his pottery. His favorite things to make are bowls and plates. "We never set out to make money; we set out to change perceptions," Suzanne told us. However, soon Troy was flooded with people asking to buy his work, so Suzanne started an Etsy store. The store took only two hours to sell out. This is almost slow in comparison to how quickly their most recent Christmas ornament sale went: it took eleven minutes to sell 650 of the ornaments made by Troy. Troy has made more than $50,000 from his ornaments and has had 26,000 people visit his Etsy store. To top it all off, 100 percent of the proceeds from his ornaments go to charities,

including Ruby's Rainbow, The National Down Syndrome Society, Hearts of Joy International, Britney's Baskets of Hope, Mile's Message, Global Down Syndrome Association, and Sea Turtle Conservancy.

Suzanne, originally frightened by the cruel internet horror stories she had heard about, has now found that their favorite time spent together is actually reading the comments and getting to see their real-world effects on others. Troy says his favorite thing, simply put, is helping people. Every day, they receive comment after comment from pregnant mothers and families welcoming babies with Down syndrome into their lives, babies that may not have been born if they hadn't seen Troy. These people discovered that a person with Down syndrome can live harmoniously and successfully with a neurotypical family.

Troy helped his family to understand that life doesn't give you what you think you want, rather, it gives you what you need. The Drake family now lives by the motto, "Don't force yourself to be who you're not. Acknowledge your unique traits and skills." Troy has also taught the Drake family that "it doesn't take a lot to truly be happy." Troy says "Don't have limitations; Try everything and don't feel pressured to do what everyone else is doing." He says that what makes him happy is pottery and family. Most neurotypical people are so distracted by what they don't have that they can't focus on the abundance of what they do have.

Suzanne tells us, "Through Troy, I see a different side of the world, and I hope you all do too."

Josh Morente

"It's just Down Syndrome."

- *Anna Morente*

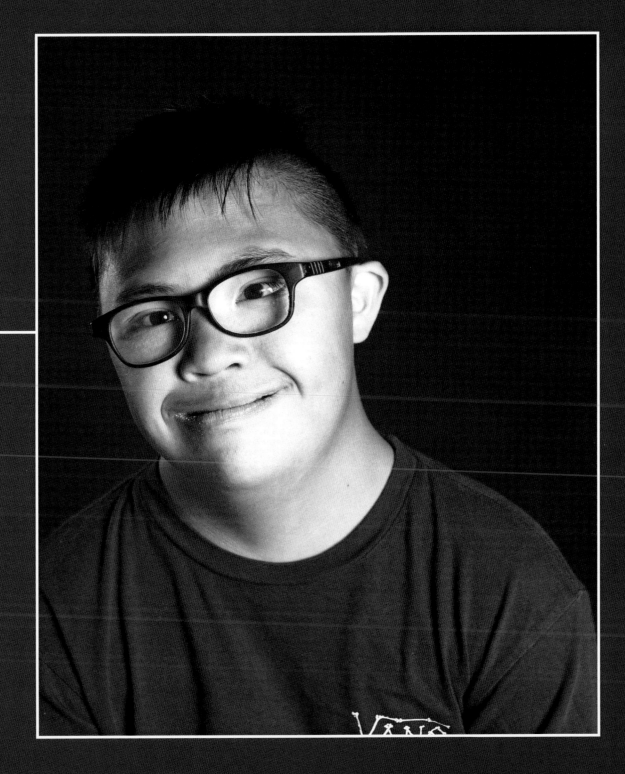

Josh Morente

Anna wasn't expecting a child with Down syndrome, but there were some significant markers. When she told her friends and family of the possibility, they said to her that it is no big deal, "It's just Down syndrome!" The family lovingly welcomed Josh, a beautiful baby that fed well at the hospital, but his parents were advised that he should stay a few days longer to be treated for jaundice. His parents were sent home, but at four o'clock the morning, they received the worst phone call: Josh couldn't breathe and had to be intubated. Josh was transferred to another hospital for further treatment. Diagnosis: duodenal atresia. His stomach and in intestines had separated after birth, hence the inability to breathe. At four days old, he underwent major surgery. The surgery was successful, but Josh remained in the NICU for six weeks. Even though Josh did not come home for six weeks, Anna made every effort to bond with the baby through daily visits, skin-to-skin time, and providing breast milk for the best nutrition. Finally, Josh was sent home with the small precaution that the doctors wanted to do monthly blood tests to monitor his liver and some abnormal white cells.

Anna took her baby home and had some amazing months with him. Everything normalized in the first year, and Anna treated him the same way she did her two other children: a middle son and her daughter, the eldest.

At twenty months old, Anna and the family were hit with heart-breaking news: Josh was diagnosed with Leukemia. The treatment for AML (Acute Myeloid Luekemia required six rounds of intense chemotherapy. "We were hopeful," Anna said, "because kids with Down syndrome seem to respond better to treatment than typical kids." Despite the challenge, Josh thrived in the hospital. In a short time, he learned how to walk and do sign language, and he never once acted like he was sick. He would eat well and point outside, insinuating his desire to go play. His family got him a

toy car to cart him around the hallways. He wheeled to each door on the fourth floor, addressing his fellow patients with kind expressions and waves. Josh became best friends with all the nurses, some of whom they still keep in touch with today. After enduring six months of intense chemo, Josh was finally sent home and has been in remission for almost ten years.

Josh is sassy, loves to cook with his mom and grandmother, finds joy in making TikToks with his older sister, and cleans the house with his brother and dad. He is very independent and a good communicator. He likes having alone time to work on himself, and he loves his family more than anything. Josh added a layer of texture to the Morente family that they never knew they needed until they realized they could not live without him. He has unified his family, so they have become a stronger unit.

Josh is a blessing because he is full of honesty and joy, so much so that people are drawn to him and his character. Josh's spunky attitude developed through his success in speech and early developmental therapy when growing up. He just completed fifth grade at a public elementary school and had the best team supporting him. As an educator, Anna couldn't be more grateful for his success at school.

Anna said her philosophy is to prepare for the worst and hope for the best, and Josh truly is the best. As a startup member of Gigi's Playhouse, Anna hopes to work toward awareness and acceptance of differences, to show people that everyone is unique in their own ways and that they can use those differences as contributions to society.

Josh is humble and witty, quick to apologize. His favorite subject is math, and he wants to be a teacher when he grows up so that he can teach others and help them learn. When asked if his life has any struggles, he said incredulously that, "I have no challenges." He is the epitome of someone with a work-hard, play-hard outlook on life.

Extraordinary

"The difference between ordinary and
extraordinary is that little extra."

-Jimmy Johnson

GiGi's Playhouse Simi Valley

Amid the chaos of a global pandemic, two moms were on a phone call discussing their disappointment. There had been talk of a GiGi's playhouse starting up in an adjacent town, and both moms were excited about the prospect. But like many other endeavors, the dream ended as the virus took over every facet of life. There were tears and frustration because both moms had daughters with Down syndrome that desperately needed a place to connect with other children like them. Amidst the tears, one mom said to the other, "Why are we crying? Why don't we start a GiGi's Playhouse right here in Simi Valley?" Everything felt overwhelming at the time, but life had slowed down just enough for the moms to do the necessary outreach, begin the inquiry process, and start building a team to bring this dream to fruition.

With over 55+ brick and mortar locations across the United States and Mexico and 200 inquires to start new locations all over the world, GiGi's Playhouse is the ONLY network of Down syndrome achievement centers in the world. Every day, life-changing therapeutic, educational, and career training programs are provided for 30,000 plus individuals. Down syndrome is the largest chromosomal disability in the country, and yet, it is the least funded. From prenatal diagnosis to

career skills, GiGi's makes a lifetime commitment to empower families by giving them the tools for success. All programming is one hundred percent free to families and is volunteer-driven.

The partnership between GiGi's Playhouse Simi Valley and David Hessemer's visual storytelling class at Oaks Christian High School began in 2021. Oaks Christian High School is an amazing school where students are nurtured and encouraged to develop their potential in academics, arts, and athletics in the context of a Christian education. Oaks Christian attracts professionals in their fields to come and teach. Mr. Hessemer used to be one of the main photographers for Nike and specialized in Humanitarian photography and now teaches photography at Oaks. He works with nonprofits to see how his students can use their art to help others in need. Mr. Hessemer and his students created this book to feature portraits and stories of people that the world perceives as different or less. The aim is to demystify disability and other differences, to change outdated narratives, and promote acceptance. The first book in this series took on the topic of burn victims. This volume is devoted to changing the perception of Down syndrome.

The Oaks Christian students learned about Down syndrome by combining didactic and experiential learning. They got to interact with dozens of individuals with the genetic anomaly, fourteen of whom you met in this book. The students' hearts and minds were not only changed, they were transformed. Many reported that the project was life-changing because they saw that people with Down syndrome are more than a diagnosis; they are complex, extraordinary human beings. This book was written and photographed by students that will ultimately shape the future of individuals with Down syndrome. Because people with Down syndrome have traditionally been separated from their neurotypical peers in educational settings, it is not uncommon for students to graduate from high school without having had any meaningful connection with someone with Down syndrome or intellectual disability. As the Down syndrome community fights for inclusion in education, this is gradually changing.

On behalf of GiGi's playhouse Simi Valley, we would like to thank Mr. Hessemer, Oaks Christian school, The Simi Valley Noontime Rotary who funded this project, and each student that participated for their love, service, and devotion to our community and their willingness to spread the word that people with Down syndrome are JUST LIKE YOU.

Words cannot express the joy I experienced watching this talented group of high school students as they created the Just Like You books. This series of books blossomed from the heart of Maren Jacobson, a high school junior at Oaks Christian. She quietly shared her dream of creating a coffee table book focused on burn survivors. She shared with her peers that she wore long sleeves and that she had been burned over forty percent of her body when she was only two years old. She shared what it felt like to live with rejection from people that were uncomfortable looking at her; that they would quickly look away when they saw her burns. Maren wanted to use the first Just Like You book focused on burn survivors to change the perception of people toward others that don't look the same as everyone else. The class embraced this project and Just Like You Volume 1 was born (published in August 2021) and is now available at most worldwide book sellers. My Visual Storytelling class that started this project were so touched by the impact that this book had on others that they wanted to create another book. After a few long brainstorming sessions, Just Like You Volume 2 took shape.

I hope you enjoy this book and visit it often for inspiration and to remind you that we are all very much alike. It was such a blessing to all of us that had the privilege of working on this book to learn that many people with Down syndrome seem to have the superpower of sharing love and acceptance with everyone. We met so many people with Down syndrome that are full of joy, courage, and forgiveness. When being around this community, love seemed to surface and it was contagious. This book is the work of over twenty five high school students and took two years to complete. These students have become a family and have dedicated countless hours to bringing this labor of love to life. I am often asked if there will there be another book, if there is a Volume 3 in the works. The answer is a resounding "yes"!

What will be the next step? These students want to see a global movement created to help bring people together by telling the stories of marginalized people and showing that all people are the

same inside. What if a community of student content creators could come together to do projects to bring us all closer together? This question was the foundation of the creation of the nonprofit Just Like You. This nonprofit and the community it builds will be a storytelling hub for content creators to tell amazing stories about people that will inspire and unite us all. This will be a place to give creatives an outlet to utilize their unique gifts to bring joy, promote kindness and create unity. This will be a place where photographers, filmmakers, song writers, wordsmiths, and other artists come together to create content that will inspire acceptance and dispel outdated narratives through the stories they create.

Please visit our website to learn more about the Just Like You movement, become part of our community as a storyteller or join the Just Like You family. We will always try our best to keep things positive and based on love. Our class spent many hours developing and fine-tuning what they believe is a universal definition of Love that will be the foundation of everything that we create. I will leave you with that definition and hope to meet you in our community. Visit our website at Justlikeyou.me

"Love is a natural force within us that embodies the purest compassion, devotion, and patience that when expressed or received, engenders selflessness, acceptance, and kindness in the hearts and lives of people."
Blessings,

David Hessemer

This book is a Just Like You Project
Created by Oaks Christian High School Visual Storytelling class
31749 La Tienda Rd.
Westlake Village, CA 91362

Just Like you Extraordinary Edition
This project is gifted to GiGi's Playhouse, Simi Valley, California, and all
proceeds from sales of this book will go directly to Gigi's Playhouse.

A special thanks to the student authors:
Isabel Davison, author of
Amy Bockerstette, Arik Ancelin, Camry Cheatham,
Matthew Blascovich, and Troy Drake

Skylar Alves, author of
Josh Morente, Tim Harris, Sophie Samaan, Paislee Karaba,
Jamie Brewer, Mia Armstrong, Delmar DeWitt

Co-Authored Stories:
Grace Key by Isabel Davison and Skylar Alves
Jaxon Bell by Olivia Medrano and Skylar Alves
Mindy Zazanis by Sofia Livia and Skyar Alves